THE RED SHOES

THE RED SHOES

Artists Book Project

Edited, Illustrated and Introduction by
Annell Livingston

Printing by Brennan Studio, Inc.

© 2011 Annell Livingston

ISBN 978-1-257-46412-8

HC74 Box 21860

El Prado, New Mexico 87529

www.annelllivingston.com

http://somethingsithinkabout-annell-annell.blogspot.com

Copyright of poems rests with authors.

For my Mother
Myrle Brummett
And for the Grandmothers

Contents

Introduction .. 1

Kathleen Brennan ... 3
Almost Red .. 3

Aase Lilleskare Faugstad .. 4
September is Already Here .. 4

Helen Dehner .. 5
Red Suede Shoes .. 5

Susan Embry ... 6
Red Shoes .. 6

Michele Steele ... 7
Red lacquered sandals .. 7

Vivienne Blake .. 9
Little Red Shoes ... 9
Red Shoes .. 9
Shed Rues ... 11

Sandy Carlson .. 12
Pretending .. 12

Pat Garthoeffner .. 14
Red Shoes ... 14

Sherry Marr (Sherry Blue Sky) ... 16
On Women and Shoes .. 16

Terresa Wellborn ... 22
Red Shoes ... 22

Pamela Sayers ... *23*
Dancing .. *23*
Creativity ... *23*

Jae Rose .. *24*
Limits .. *24*
This is not Kansas ... *25*
Alice and the Candle ... *25*

Barbara MacKenzie .. *27*
The Red Moccasins ... *27*

Joy Jones .. *32*
The Red Shoes .. *32*

Marilyn Moorhead .. *33*
Blood Stains .. *33*

Annell Livingston ... *34*
No More Talk of Darkness .. *34*

Elizabeth Crawford ... *36*
About the Dead Woman and The Dream of Red Shoes *36*
More About the Dead Woman and Her Dream of Red Shoes *37*

Notes on the Poets .. *39*

Acknowledgements ... *43*

Introduction

> I stand in the ring
> In the dead city
> And tie on the red shoes
> ...
> They are not mine,
> They are my mother's,
> Her mother's before,
> Handed down like an heirloom
> But hidden like shameful letters.
> --Anne Sexton

The red shoes are a symbol of creativity for women and our legacy. It is this legacy that the Red Shoes artists book project addresses. And it is this legacy that contemporary women have forgotten, or do not know.

Women today are able to grasp the pen, hold the brush, sing and dance because of the women who went before, who struggled in isolation, which felt like illness – alienation, that felt like madness – obscurity, that felt like paralysis to overcome the anxiety of authorship that was endemic to their literary and creative subculture.

The women included in this collection are diverse in style, approach and form. Each seems to be remaking, renewing, renaming, re-experiencing and recasting old ideas about the Red Shoes, and the meaning in their lives.

"Women are writing wonderfully exciting, approachable, rich, funny and moving poetry (and prose) that can speak to a wider readership than it usually gets. Women are writing much of the best poetry being written, but remain poorly represented in anthologies, textbooks, reading lists, awards and every other

institution controlled by white men who like the way things are presently run just fine. Women are still mostly read by women." –
Marge Piercy, Early Ripening

The artists were chosen for this project simply because I love their work. There are many others that could have been included; perhaps this is just the beginning.

I conceived the idea of a Red Shoe artist book project, while reading the Madwoman in the Attic, by Sandra M. Gilbert and Susan Gubar. They explain that the women of the nineteenth-century had what was called "anxiety of authorship," – a fear that she could not create because the act of creating would isolate or destroy her. The symbol of the red shoes used in fairy tales was the symbol for the creativity for women, i.e. Snow White, The Wizard of Oz, Cinderella, and many others.

>Feet bound securely
>Toes turned under
>Fire licks tenderly
>Red Shoes insist
>They are made for dancing
>Glass shoes will cut
>Red all over
>But without fear
>Many women today
>Slip on the red shoes
>And they dance

Kathleen Brennan

Almost Red

I never owned a pair of red shoes Cordovan, yes…you know, the penny loafer type. I loved those shoes and I put my shiny new pennies in them and wore them during the teen years.

When I was five, I remember coming home from the shoe store with a new pair of reddish brown oxfords… I always loved tie up shoes. They were more secure feeling. But those little devils were not exactly fitting the way I thought they should.

It was summertime and I went out to the back yard with a pair of scissors. I carefully considered the necessary adjustment and proceeded to cut the tongues out of them. I put them on and decided they were a good fit, but realized that I was in a heap of trouble, once I was found out. Sure enough my parents were horrified by my action. But I wore them, knowing I had done what needed to be done!

2011

Aase Lilleskare Faugstad

September is Already Here

September has stolen in. I see from my study window
A row of lovely green elms, a grey stonewall of irregular rocks
With russet and yellow vine hanging over it,
A copper beach, black and heavy.

On my windowsill: a pair of red children's patent leather shoes,
The first "best" shoes I wore.
A brown stained wooden box from New England
With acorns and wide-open cones, ready to spread seeds
In all directions of the sky;
A flower made from herbs with an artificial white, starched collar.

On the other side of the sill: a small glass of black Indian ink
Waiting for a pen drawing; two tawny speckled snail shells
From forgotten beaches,
And a magic, lucky stone with a hole right through it,
Which the ocean has surged over,
Found in Rye Harbour, where you can look towards Dover,
And in clear weather almost to the coast of France.

I try to reconcile myself with autumn,
Laying on my window-pane its mute, wet hand;
The way I every night in dream now try
To reconcile myself with enemy and friend.

From "The Tide is Coming in", Solum Publishing House, Oslo 1989. Translated by the poet.

Helen Dehner

Red Suede Shoes

She was too young
For those shoes
Not a woman
Still a child

What was he thinking

She was an innocent
Those shoes screamed 'easy'
Slip them on, lace them up

What was he thinking

She was not ready
Daddy's little girl
Too much too soon
Red Shoes tarnished her soul

What was he thinking

2010

Susan Embry

Red Shoes

My Mother spoke of them
In hushed tones.
Irreverent symbols of lust,
Too much fun,
Too much dance.

Her tone said
"Not for ladies,
Longed for,
But not acquired."
Hands off.

Red boots,
More to my liking.
Hell bent, tougher fabric.
Good for kicking important rocks,
Sand in your face. Fitting for a tomboy
Like me
With pigtails.

Image is everything.
Is that what I heard?

2011

Michele Steele

Red lacquered sandals
with red velvet thongs
like I had when I was a child
a souvenir from a relative
who had visited Japan.
I didn't imagine then
that decades later
I would make my home here.

More than a decade has passed
since I bought the red sandals
for my child,
now almost grown.

We were at the summer festival
in our Japanese summer wear
and my three-year old son
spotted the shoes.
Full-moon face
lighting the night,
his big, round eyes gazed with longing.
They were glossy red
with a little girl
painted across the soles.
Kimono-clad, black, bobbed hair,
just like the girl on my sandals long ago.
As I paid the shopkeeper
I was solemnly told by a well-meaning
Japanese friend,
"Those are usually worn by little girls."

(As though I might not understand,
coming from another country and all).
"I know," I told him as I placed them
on the ground and let my son's plump,
eager feet slide into
his new, wooden shoes.

He wore them for a season.

 2011

Vivienne Blake

Little Red Shoes

Pudgy little feet
I'll never find shoes to fit.
 But you must, Mum
 I'm ready to walk
 And the floor is cold and hard.
Little round red shoes
For his round red feet
So pretty I have to kiss them –
The feet, not the shoes.
 Oh! Don't do that, Mum
 It tickles and makes me giggle.
 Ouch! What are you doing?
It seems so hard that you have to grow up,
Wear shoes all the time, behave like a man.
Perhaps I won't buy them – lay carpet instead
To soften the floor and keep your feet warm.

Red Shoes

You're not having red shoes.
Mum was cross.
 Please, Mum they're gorgeous.
Red shoes no knickers.
 Look, the heels aren't that high.
 I could dance all night in those.
Oh, no, you won't – you'll be back by ten.
 Does that mean you'll buy them then?
She can't deny their beauty.

We'll see. Try them on.
> Comes Friday, excited,
> Twirling this way and that
> In front of the mirror.
> First bra, first nylons
> Stick-out petticoat
> Swirly skirt, frilly blouse,
> Waspie belt and those shoes…

Dad takes one look and hits the roof.
> What were you thinking?
> She's only fourteen –

Out of the question going out like that.
> But Daaaad…

Mum sticks up for me.
She's only young once let her go.
> So he did and I went
> To the school Christmas hop:
> Had a breathtaking time
> As I danced with a prefect,
> The new cricket captain, sublime,
> And that goof from four B.

Red shoes danced me all the way home in a dream.

———

SHED RUES

cast off regret
forget the blues
take a jet
to a faraway place
wearing those red shoes.
2011
©Vivienne Blake 2011

Sandy Carlson

Pretending

Never in my life
Have I owned red shoes

Though my daughter and I
Would sometimes try them on
On rainy days
At the store that sells seconds and odd lots
When she was very young.

Together we would pull ourselves
To the heights of scarlet stilettos
Click our heels in spangled flats
And wonder at the heft of the ruby Doc Martens
We never climbed into.

These were the years she'd watch
Lord of the Dance over and over
Admiring the vamp in the red dress,
Whose lithe movements
Dared us to respond
In kind in the living room.

On rainy days now
The pure joy of those memories
Come to us like an invitation.

 2011

Pat Garthoeffner

Red Shoes

I:

I am very open, - open to discussion, open to new discoveries, open to new changes, open minded and opinionated.

I am not afraid.
I am younger than necessary and older than I am.

Beauty:

I love beautiful things and things that are beautiful.
I love beauty for beauty's sake.
Beauty makes me happy; makes me smile; makes me laugh.

Red:

Red makes everything shine makes it glow; makes it rosier.
Red looks good with green but also stands alone.
Red is courage and life.
Red is my favorite color.

Shoes:

My friend said you must have lots of red shoes
I had no red shoes.
Red shoes make you want to dance.
When I put them on I am beautiful; I do a beautiful dance.
I bought the red shoes; they are beautiful; they are very tall;
they feel good on my feet.

Red shoes look good sitting on my dresser.
I love Red Shoes,
I have one pair.
That is all it took—

 2011

Sherry Marr
(Sherry Blue Sky)

On Women and Shoes

I know about women and shoes,
but I seem to be
missing that gene,
so any poem written by me
on that topic
has to be about not-shoes.

What I wear on my feet:
Crocs,
for slipping on
to run the dogs in and out
and down the street,
calf-high mud-boots
for heading to the barn
in rainy weather,
a battered pair
of running shoes
with clunky laces,
that have to be
wide enough
for comfort
-rather like
a flat bottomed boat-
to accommodate
my egg-sized ankle cyst,
and which I replace
when the soles fall off
every three years,

give or take,
whether they need it or not.
(Note: this month
the bottom sole
of my left shoe
was actually flapping
before I noticed
it was Time.)

I have a daughter
who wears
a fascinating array
of footwear,
including combat boots
for Kicking Ass,
cool strappy things
for dressing up,
anything from platform heels
to fitness shoes,
and all that lies
between.

She did not get
her sense of style
from me.
When we go out,
beside her
tall, beautiful elegance,
I feel like the frizzy-haired
Witch Down the Lane,
in my baggy sweatshirt

and only pair
of jeans.

Yesterday I met
an old hippy
over in Coombs.
Our laughing eyes
recognized each other.
(It must be something about
The Frizzy Hair ☺)
He told me
he was in Haight Ashbury
Back in the Day,
that he wore
thigh-high leather boots,
with buckles
in which he promenaded.

Back in the Day,
I wore polyester,
had never heard
of jeans,
and pushed a buggy
with three little kids in it
inside the strait jacket
of a conventional marriage
where I didn't fit,
with my big unwieldy
unconventional spirit,
that kept bumping up against
the edges and the confines
I was kept in,
till the madwoman finally
burst out
from her prison
and was no longer mad.

In those days,
while in desperation
I pushed my buggy,
I watched,

with awe and envy,
the benign, coolly-dressed and
totally FREE-spirited beings
wandering smilingly
up and down Fourth Avenue,
wondering how
they learned
to be so free,
to be so much Themselves,
while I still felt
such a non-person,
trying on a role
that didn't fit.

I just missed
that freedom bus
by five seconds,
pushing my buggy along
a parallel street,
just one block down.

When I broke free,
I remember pushing
my giggling babies
in that same buggy,
as I hippety-hopped
down the hill,
all of us
laughing and leaping,
heading us all
towards a happier life.

I made up for
missing the 60's
later,
in coffeehouses
in the 80's and in
The Land of Refugees
from the 60's,
in Tofino
in the 90's.

My spirit never tried
to stuff itself back
into that little box
again.

The only red shoes
that ever spoke to me
were Dorothy's,
on that journey she made
away from
and back to herself,
where she found
she had always
had the power inside her,
and found her home
within,
where she had started out.

I have worn out
a lot of running shoes
this lifetime,
walking through
some of
the most beautiful
landscapes
in the world.
All I ever needed
was a pair
that fit me,
that can carry me
into the wilderness
I love.
A pair
I kick off
at the door
when I come home
tired,
slide back into
every time
I'm heading out.

How many more pairs
and pathways
are there left me?
There's no knowing
but there's one thing
I know for sure:
when music
from those years
calls to my spirit,
I can still kick them off
and dance a lick or two
across my empty room.

2011

Terresa Wellborn

Red Shoes

I was thirty-three
I wasn't sure I could carry it off,
Throated birds sprouting as feet,
Sunsets,
A catastrophe.

They rushed over my toes,
I couldn't help it,
They spoke in slick tongues,
An August heat.

They unbuckled like the
back porch unlocking rain,
The color you hear in your
veins, colliding.

I wear them every day
Now, they
Speak nothing of
Desire.

2011

© 2011 by Terresa Wellborn. All rights reserved.

Pamela Sayers

Dancing

Red satin shoes that tap
Along the skyline.
Resonating through my brain.
Formations flow…
Sequins sparkle causing rainbows.
Illuminations – Frivolous…
Limitless beginnings and endings.
Twinkling – drops of contour.
The future is crystalizing promises,
Comforting infinities.
Happiness surrounds, butternuts and chicory,
Lining a cloud above, clicking and repeating…

Creativity

Restless hands, a desire to create
Never enough time…
Staying busy is important
Like water that rushes down
A mountain and becomes frozen in midstream
Fingers move in synchronized efforts,
Forming – reaching – trying to make sense
Light through a window catches shadows
That spark interests and ideas
Creation, imagination, allows breathing, slow and steady
Pyramids pile high, placing layer upon layer
As we construct what we believe,
An expression of ourselves

2010

Jae Rose

Limits

I go to the railings for my morning embrace. The three metal bars hug my knees and chest as I lean over them. There are no cars in the car park today. Just post holes and frozen puddles. I look at the lady trying to negotiate the ice and melting snow in her hooker shoes. I look at my own feet. Same size and shoes as an eleven year old boy. Stuck, stuck, stuck. I kind of wish I had the courage to step out in red, plastic stilettos. Maybe it would invite more flexible hugs.

It was another restless night. Awake in my bed at 2 a.m. I heard voices in the car park. Something about find a lone female. Voice in a walkie-talkie. There are lots of hiding places for heads that need rest in this complex. I wondered if they were looking for me. If anyone is looking for me. In my head I have already disappeared and there is no one left to find me. In total waking, I know my body will never get past the railings. They stop me. Hold me. Turn me away.

I am so scared of Monday. It is coming like a freight train and I don't want it. I don't want to be seen. I don't want to be touched. I don't want anyone cutting into my existence I am happy in my darkness. I am happy drawing the curtains and lying on the floor treading time. It is a place of non-being. It keeps me safely tucked up within my limits.

I hurry home with food I shouldn't eat. With books I will never read and paper I will never fill with pictures. I like to keep my arm close to the wall. My feet aligned to the inside of the kerb. Like doing a puzzle from A to B. The path of least resistance. I try and look at the things that make other people smile but my face contorts into a rictus and I feel even more exposed. How do words

come so easily to them. Movement so effortless. Every muscle and thought grinds inside me and rubs me raw.

I pass the shoe shop. In the window the red shoes sparkle under the artificial lights.

This is not Kansas

And I have lost my ruby slippers and cannot return home.

At best
This place shouts at me
You are nothing.

At worst
It ignores the fact I am still here.
I disappear into its shadows and ghosts.

I cut the powder and drop myself into the tornado.
But I know that when the color fades and my head stops turning

I will still not find my home.

Alice and the Candle

I take Alice to the church.
She is my only friend.

Although I only hear her in my head.
And I only speak to her in my dreams.

The red lady pays ten pence for a candle and kneels.
A small price to pay for a big guarantee.

I keep my pennies in my purse.

The man in the hat chases up the aisle saying
I love you so much.

This is why I rarely leave the house.

When they have gone Alice rests her hand on my head.
She lets me cry a pool of tears and we float in it together.
The salt eating into the holes in our skin.
Quelling the fire.
Like kisses.

We drift in the water until the red land's candle burns out.
Then all I can feel is the wooden seat.
The cold in my breath.
The cold inside no blanket can warm.

For a moment the clock ticks and I hear voices outside.
I look around me.

Scared

Alice is so small she can be blown away like a pencil shaving.

I often wonder if she is there at all.

2011

Barbara MacKenzie

The Red Moccasins

There was a beautiful Dakota maiden having lived sixteen cycles of the earth at her mother's side, for sixteen of those cycles she walked barefoot feeling the movement of the earth below her and laughing at the meadow when it called her name.

On the first morning of the new cycle the maiden awoke to her mother's voice. "Daughter of the Dakota arise from your sleep, you must set out on a journey of great importance." The maiden did not understand what her mother was speaking of and quickly arose from her bed. Her mother continued, "Daughter you must set out towards the River of Life, there you will need to fetch water for our people that they may remain a strong people and continue to prosper throughout the ages. I will give you instruction; first you must follow the South Wind as she will be your guide and keep you on the right path to the river. You must be cautious of the other three winds for they will try to pull you to their direction and should you follow you will be lost, never returning to your tribe and family. When you get to the River of Life you must gather as much water as you can carry and follow your footsteps back to the Dakota People."

So with the instructions now in her heart, her mother gave her a leather purse filled with food enough to nourish her on the journey towards the river. The young maiden at first was frightened as she set out to complete the task her mother had given her but the South Wind was so soft and comforting that it quickly calmed her fears. Soon she was feeling the freedom of self-discovery and the warmth of the earth beneath her feet.

As the moon placed her face in the sky that first night the young maiden made a bed of leaves and twigs next to a cave like rock and started off to sleep. Within an hour of falling into a dream she

could hear a voice calling out to her, "Daughter, Daughter of the Dakota why nestle yourself to a rock when here I have for you comforts and great gifts, here just to the east of your bed sits the great forest. It is within the arms of the forest you will find everything you need and want, ever abundant and ever filled with mystery and magic."

At that the maiden heard a long loud howl of a wolf becoming frightened and wanting to run to the east towards the great forest and hide in its welcoming arms. But suddenly remembered her mother's words, "be cautious of the other three winds for they will try to pull you to their direction and should you follow you will be lost", she laid her head back on her bed, closed her eyes and fell back asleep.

The next morning she woke giving thanks to the Great Spirit and taking food from her leather purse she ate to have the nourishment she would need for the day's journey. The second day the sun was warm and filled the whole sky bright allowing the eye to see for miles in every direction, but she was staying true to the course she was instructed to take, marking her footsteps so she could easily find her way back to her family and her people. Then along about midday when the sun was at its highest she heard the screeching of an eagle. He soon swept down right in front of her veering out towards the west, her eye following his movements of beauty and grace. As she raised her head to keep his path in sight her eye became fixed on the most beautiful site she had ever seen, it was a snowcapped mountain range of magnificent proportions radiating in green to white to blue in the noon sky. It was as if she could hear the winds from the highest peaks singing to her, "Daughter Of the Dakota come, come sit with me. Come let your feet climb my majestic paths, higher and higher I can take you and you can become one with the sky and with the sun. Leave your journey and step west towards my beauty and my wonder."

The maiden raised her foot to veer west when she again heard the screech of the mighty eagle stunning her to her senses and reminding her that she would be taken away from her destiny of bringing the Water of Life back to her people if she took that step. So she took a step but to the south and continued on her path.

On the second night the South Wind guided her to a creek side so she could eat and drink refreshing herself for the next day's travels. There too was provided an abandoned fox den that would give her shelter for the night. Unaware of the danger around her, she sat up late by the creek admiring the southern sky, when a fierce chill came from behind her to the point that movement was almost impossible. The North Wind had made his presence known and was requiring her attention. "Daughter, My Daughter of the Dakota you belong to me and I will have you even should I have to take your breath and still your body. Come to me that you may live with me, I will dress you in white and crystals and you will be my bride."

The maiden could not move, and everything around her was turning to ice. Snow began falling around her when the South Wind heard her cry out, "Someone, please hear me and save me from such cold fate." The South Wind blew and sent warmth enough for the maiden to pull herself into the den for shelter and build fire to unthaw herself. That night she dreamt of water against, a red sunset and an Indian Woman dressed in white buckskin. Now came the last day of her journey and she could sense and hear the sounds of running water while the image of the Indian Woman stayed with her throughout the day. She was soon close to the sound of the river and knowing it must be in front of her she could not see it. Coming closer still she saw that the River of Life was banked for miles with thick thickets of brush and thorn. As she took her first step she realized she could not continue because her bare feet had nothing to protect them from being cut to shreds. The young maiden was tired and weary for she had walked all this way and now her journey would be unfilled if she could not get to the river and bring back the Water of Life to the Dakota people and she wept and wept.

Then with the sense of a hand to her shoulder, she raised her head and looked up and there stood the Indian Woman dressed in white as she was in her dream. "Daughter, Daughter of the Dakota do not weep, do not be discouraged for you have everything you need to pass through the thicket and obtain the sacred waters. There is your purse, the purse your mother ensured you carry, take it, cut it and sew your self a find pair of moccasins that will protect your feet from the thorns. Do this and you will be protected from any

further harm". Then the Indian Woman was gone, leaving behind six empty gourds and a knife.

With renewed spirit the maiden quickly began working on constructing the moccasins for her feet cutting the leather purse equally for each foot and leaving enough leather string to tie all the gourds together that she may gather the water and carry it home. She worked all night cutting and sewing the moccasins, ate what was left of her food, put the new moccasins on her feet and fell fast asleep. Again she dreamt of the Indian Woman in white, who blessed her in the dream and took her to view a meadow where children were playing and laughing and calling out to their mother. Her heart rested well that night.

In the morning she arose, placed the gourds tied together around her shoulders and headed through the thicket of thorns. It seemed to be hours of slow progress that was bringing her to exhaustion when she could feel the water, the spray of the cool water splashing against the rocks of its bank. Continuing a few steps further she was there standing at the River of Life and gave thanks to the Indian Woman that guided her feet through the thicket. She looked down at her feet as the water splashed up and noticed that as if by magic where the water drops wet her moccasins they turned a bright red in color. So in wonderment she placed one moccasin covered foot then the other into the river. When she stepped out from the water both moccasins had turned to the purest of reds and with that sign she became fully awaken to the real purpose of her journey.

Quickly now she filled each gourd with the Water of Life placing them on her shoulders and headed out from the thicket to follow the path of footsteps back as her mother instructed. The South Wind again guided her this time pushing her from behind giving her strength to move fast and with the grace of a woman. The red moccasins protected her and steadied her feet to ensure the water would make it safely back to her Dakota people.

On her arrival a large part of braves announced her return and her Mother came running to greet her daughter. "Daughter of Dakota you have returned, you have brought the water safely to us from the River of Life and we shall celebrate you for you are no longer just my daughter, but the Daughter of all the Dakota having ensured their strength and their longevity."

A celebration was held in her honor and with it a wedding to a strong brave of many feathers. Together they lived among the Dakota people on the plains and on its meadows, filling them with joy and the laughter of six Dakota children of their own. And as the once maiden, now mother, watched her children grow she held sacred the red moccasins of her youth even as they faded with the color of her hair.

2011

Joy Jones

The Red Shoes

A Rondel

She danced through the night. Her shoes were red.
She rang her bell of tulle and ribbons, dress of dreams.
The master cued her moves and sewed her seams
And made her body over like a doll's without a head.

He choreographed her pas de deux, a masque of the dead.
She must be only air, her bones hollow as moonbeams.
She danced through the night. Her shoes were red,
Stiff her bell of tulle and ribbons, dress of dreams.

She danced through the night. Her shoes were red,
though cream when she began the final themes.
She rang her bell of tulle and ribbons, dress of dreams.
Violins bowed the razor while she bled.
She danced through the night, her shoes were red.

January 2011

*Note licensed under Creative Commons License 3.0 U.S.

Marilyn Moorhead

Blood Stains

Let your beauty stain you
Crimson upon
My skirt
My womb
My thighs
My lover
My babies
My words
My landscape
My heart
My soul
My canvas
My shoes

2011

Annell Livingston

No More Talk of Darkness

The sun is high above Taos Mountain
The fallen snow glitters before me
The beginning of a new year
The trail is marked
As distinct as Dorothy's yellow brick road
This year will be the year
We'll put on the red shoes
We'll be off to see the Wizard

No more will the wolf emerge as victor
And no more unhappy endings
Where warnings are issued to women
Of the advances of men in wolves clothing
Perhaps this year will be the one
No more talk of darkness
Forget those wide-eyed fears

The red cape, and the red shoes
Symbols of female creativity
Women of the 19th century
Afraid to put on the red shoes
And terrified of the cape
This year will be the year
No more talk of darkness
Forget those wide-eyed fears
In the old tale,

The grandmother was eaten by the wolf,
As women of the 19th century were
When they attempted the pen

This year let's
Slip on the red shoes,
Put on the cape,
Embrace the possibilities
No more helpless females
No more talk of darkness
Forget those wide-eyed fears

2010

Elizabeth Crawford

About the Dead Woman and The Dream of Red Shoes

The dead woman didn't like the darkness, wanted color.

She thought about red shoes.
Thought she could use them to move with ease from here
 to there, go anywhere she might please
 (she was restless, filled with feckless ideas).
The dead woman knew she was dead, of course.
Wanted only to dig toes in whatever fields she might fallow,
 callow of meaning, buried in shallow sand on spit
 of land that pointed toward sea,
 but never quite reached it.
The dead woman thought because she was dead,
 she could dance like Mr. Bojangles, clicking
 her heels to impossible heights, alighting
 back home with mere flick of boney ankles.
She planted dreams, like kisses, on cheeks of small children,
 thought they would bloom, fill rooms
 with sweet fragrance.
Then had to watch them perish, a slow lingering death,
 never given breath of permanent existence.
With nothing of nurture to keep them alive, they swiftly
 wilted, tilted in leaning towers of dimming powers,
 collapsing one on another.
Soon crashed with huge splash into sea that swallowed them
 whole in cold liquid bosom.
The dead woman signed, she had so much time to fill.
Knew she must release illusive red shoes.
Must plant bare feet in rich moist soil, actually do toil
 of feeding her dreams, nurture them daily,
 bringing each one to its own fruition.
The dead woman knew she must begin, again.

More About the Dead Woman and Her Dream of Red Shoes

The dead woman couldn't see her feet, of course.

She couldn't feel them either.

So, she dreamed of dancing in red shoes, through eternity.

The dead woman danced with a cave man.

She dreamed of dancing with a pauper, a prince, and a political
 appointee, a chef, a truck driver, an accountant,
 a research biologist, and a university professor.

But, none of them noticed because she was a dead woman.

The dead woman laughed, she sang, she threw herself
 into the dance. She moved.

She knew she was no more than a fleeting whisper, momentary
 vapor, a slip of air to be brushed away with flick
 of a finger, a shake of the head.

The dead woman went right on dancing, trying to be whatever
 was needed.

She so wanted to be more than invisible, more than dead.

The dead woman dreamed through eternity and into the next,
 Always dancing in red shoes

The color excited her, spoke of passion, pursuit, put-off
 prolonged dreams finding fulfillment

She dreamed of sneakers, velvet slippers, flats and strappy
 stilettos, died leather moccasins, and hard vinyl crocs,
 all of them red: red like blood, like living.

The dead woman dreamed that all women everywhere wore
 red shoes: maids to matriarchs dancing their dreams
 to completion.

She dreamed through two centuries, until the Universe was filled
With laughing women, all moving toward individual
 dreams in red shoes.
Satisfied with her creation, the dead woman rested.

 2011

Notes on the Poets

Kathleen Brennan lives in Taos, New Mexico. She is a photographer, whose diverse body of work ranges from portrait to documentary, natural landscape to urban scenes, and provides an enduring testament to the transformative processes of our world. Brennan Studio. Inc. offers Brochure and Fine Art photography – Curatorial and Printing Projects. www.brennanstudio.com

Aase Lilleskare Faugstad lives in Norway. Aase is a poet, translator, painter and teacher for thirty years in middle school and junior college. She has published eleven books among them; six collections of poetry, one short story collection, selected poems in collaboration with graphic artist Kjeld Stub, selected poems in Norwegian and English in cooperation with photographic artist Kay Isaacson, and selected poems, Villanden Publishing House, 2008. She is represented in numerous anthologies in Norway and abroad, e.g. India. Editor and co-editor of poetry anthologies. In 1991, The Norwegian Book Club published her presentation of poems in English from many countries, Straumar (Streams). She has three daughters and seven grandchildren.

Helen Dehner lives in Bend, Oregon. She has been writing for more than thirty years. At first, it was homemade birthday cards with poems tucked inside – poems and eulogies read at funerals and memorial services of loved ones, poems about relationships --good and bad. Poetry was my outlet, my therapy. Writing poetry also helped me through the last five years of my Mother's life. It was agonizing to watch as Alzheimer's ravaged her brain.

In 2008, I launched Living Boldly, a blog about everyday life, with a bit of my poetry thrown in for good measure. In April 2010, I created a second blog, Poetry Matters, which is devoted to the creative (sometimes quirky) side of my brain. I continue to be

inspired and motivated by the many talented writers I now call my "blog friends." http://wooniestest.blogspot.com

Susan Embry lives in Taos, New Mexico. She is a transplanted Texas writer and advocate for self-empowerment. Her adobe home is surrounded by walled gardens, which protect her cats from coyotes and help grow the flowers that attract birds, butterflies and bees. Inside the rooms are filled with red. http://yourspiralnotebook.com

Michele Steele lives on the side of a quiet hill with her two sons and a cat. She teaches at a university in Japan.

Vivienne Blake lives in rural Normandy in Northwest France, with her retired dentist husband and spends her days quilting, writing, and blogging. She is potty about poetry, passionate for patchwork, family, friends, music and a quiet life. She has studied for seven years online with the Open University culminating in the pomp and ceremony of a degree. Last year, life became dull, until she found the Napowrimo 2010 and other poetry prompt sites, which she said, "Perked me up again." http://vivinfrance.wordpress.com

Sandy Carlson lives in Woodbury, Connecticut. She is a middle school reading teacher. She has lived in Connecticut all her life except for a few years in Ireland and the too little time they spend daydreaming every year in North Carolina. Sandy has a daughter who has a dog and they are very happy. www.sandycarlson.net

Pat Garthoeffner lives in Pennsylvania. Pat paints, draws, sings and dances as a celebration of life. It seems odd to Pat, but it is easier for her to write, when the occasional "downs" of living affect her. She is moved to put her thoughts to paper so she can share what she is feeling." Even though she didn't have a particularly good time growing up, with her Mother, she wrote a poem for her about ten years ago. She says, "It moves her to tears each time she reads it. Music brings back memories; paintings bring back memories of feelings, but words can express exactly what you are feeling when you wrote them. When you read them later, you know again those feelings, which you may never feel exactly the same way again." Garthgallery@comcast.net

Sherry Marr (Sherry Blue Sky), lives on Vancouver Island, which is on the west coast of Canada. A writer since childhood, she writes poetry, prose and often memoir. At her website you can read her

poetry and see her photography which focuses on nature and the landscape of the west coast. A concerned environmentalist and activist, she has had a lifelong love affair with the natural world. http://stardreamingwithsherrybluesky.blogspot.com

Terresa Wellborn is a fourth generation desert dweller with a rock garden to prove it. She is a librarian, thrift store enthusiast, and chocolate stasher. Terresa has a BA in English Literature from Brigham Young University, an MLIS from Jose State University. She is writing her way to a book. She dishes on panic poetry, and literary addictions at her blog. http://thechocolatechipwaffle.blogspot.com

Pamela Sayers lives in Puebla, Mexico. There she teaches English, and she does a bit of translation work. She lives with her husband. They have four dogs, a cat and a bird. She loves to write, read, and paint. Pamela enjoys quite times at home with family and friends. http://flaubert-poetrywith me.blogspot.com

Jae Rose lives in rural Devon in the United Kingdom, which she says is "no Kansas." She has had many jobs including working as a healthcare provider and educator. She suspects that everything she has seen and done, is just a story waiting to be written down; and there is her vocation. Jae has visited many places, but is still looking for a place to call "home." She hopes if she clicks her red shoes three times she may find that place. Jae has been writing a blog for the past two years. Writing and sharing words is what makes Jae happy, that, and her wonderful sister. http://jaerose-jaerose.blogspot.com

Barbara MacKenzie (bkmackenzie) is a poet and freelance writer livings in Northern California. Her Great Grandmother was a full-blooded Dakota Sioux orphaned during the Indian Wars of the 1860's in Minnesota. She has been writing poetry for several years and currently maintains a writing and poetry site called, Signed...bkm, and has come to be known in the poetry community as bkm. Barbara has been a featured poet at various poetry websites including Poets United, One Stop Poetry and Catapult to Mars. You can read her poetry and contact her through her blog at http://signedbkm.blogspot.com

Joy Ann Jones was born in Evanston, Illinois. She grew up in Evanston and in Chicago, Illinois. In the '50's and the '60's, she lived

briefly in Madison, Wisconsin, and San Francisco, California, before settling down and finishing the growing-up process in Oklahoma. She started writing and working when she was 16, doing everything from running a cash register to waiting tables.

She made a career in horticulture. Now retired to the "sticks" to garden, read, write and enjoy life with her husband of 16 years and two insanely lovable dogs. http://versiscape lifesentences.blogspot.com

Marilyn Moorhead lives in Santa Fe, New Mexico. Her love of words began at age three upon her immigrant Uncle's knee in Irish Harlem as he read Chaucer to her. Now, she finds communion in cobalt skies above her, the mountains, and the expansiveness of the ever-changing landscape. She sometimes, in celebration of life, lends her voice to the magnificence of all that is and was, with words, song, and ritual. Join her at: whiteowllala@gmail.com

Annell Livingston lives in Taos, New Mexico. She grew up in Houston, Texas. She has been painting for almost five decades. She has been writing seriously 15 years. Annell is interested in artists book projects that include a variety of creative processes. When the idea first comes to her, it all seems so simple. Then she realizes in order to accomplish this "simple idea," she will either have to enlist help, or learn something new. She also likes to incorporate found objects that show the life of the object through use and wear. She is learning the craft of book binding for her unique book projects. www.annelllivingston.com
or http://somethingsithingabout-annell-annell.blogspot.com

Elizabeth Crawford lives in Green Bay, Wisconsin. (She is retired, divorced, has four children and numerous grandchildren.) She has been writing for almost thirty years. She came to poetry late and feels she still has much to learn. She is published both in poetry and prose, and before retiring was a free-lance Writing Instructor. Elizabeth has been blogging for three years and feels she has found "home" in the writing and poetry circuit online. Her poetry can be found at http://soulsmusic.wordpress.com and http://claudetteellinger.wordpress.com

Acknowledgements

I would like to thank the artists for their own unique writings about the "red shoes" and for their permission to use their writings in my Red Shoes Artists Book Project. I wanted this project to be like a multi-faceted stone and the writings of the artists featured in the book have made it so.

I would also like to thank my sister, Maggie Steele, who is always enthusiastic and supportive of my ideas.

I would also like to thank my partner, Ward Estes. He is always supportive, when I tell him, "I need fresh eyes or I need to bounce ideas off of someone who knows what he is talking about."

I would also like to thank my friend, Kathleen Brennan, featured in The Red Shoe Artists Book Project. She is a photographer extraordinaire and has done the photography and the printing for the unique book.

www.ingramcontent.com/pod-product-compliance
Lightning Source LLC
Chambersburg PA
CBHW021932170526
45157CB00005B/2287